Mimi

The Story of Norman Rockwell's "Doctor and Doll"

by Mary Moline

Illustrated by Patti Reeder Eubank

RUMBLESEAT Press, Inc.

Greensboro, Pennsylvania

Dedicated To
THE CHILD THAT LIVES
WITHIN US.

Once upon a time there was an artist who understood people almost as well as he could paint. Norman Rockwell earned the title of "America's most beloved artist" because he painted ordinary people sharing common experiences. The great popularity of Mr. Rockwell's art is attributed to his success in appealing to the adult in every child and to the child in every adult.

Mr. Rockwell was at his best when he allowed his brush to be nudged by his imagination. He dedicated himself to painting life as he thought it should be. He looked at life and people in a unique and refreshing fashion. This "oval window" view of our world enabled him to paint life as he thought it should be...always avoiding the ugly and disrespectful.

In this series of Norman Rockwell Character Stories I shall continue in the Rockwell tradition of stressing the importance of the seemingly unimportant.

Mary Moline
Greensboro, Pennsylvania

There is no way of knowing precisely how Mr. Rockwell came to paint "Doctor and Doll," but one could imagine that he looked out of his studio window on a blustery winter day to see one of his favorite little friends, Mimi, hurrying down the street cradling a doll in her arms.

It was not unusual for Mimi to take her dolls out for a stroll in her blue buggy with the big white wheels.

Today, however, Mimi carried only one doll, and she held it in her arms in a very special way.

She aroused Mr. Rockwell's curiosity as he watched her from his special oval window.

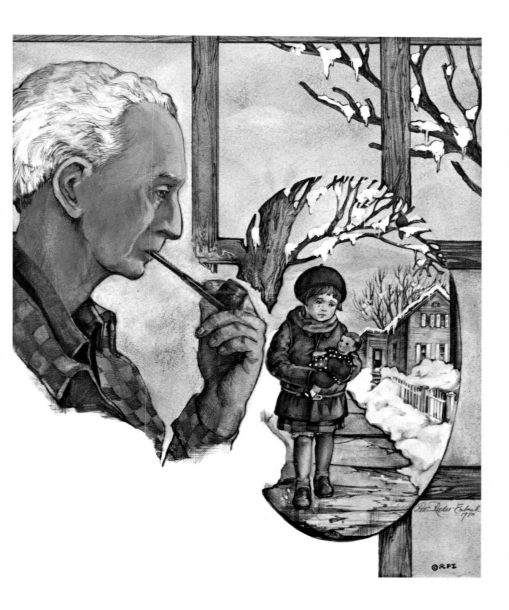

He recognized the blue and red gingham dress; the red beret, green jacket and tan scarf were also familiar.

Mimi did not watch where she stepped and she stepped in every puddle between her house and the corner.

Mr. Rockwell shook his head and chuckled at the sight...he was indeed intrigued.

He watched her slosh through the puddles of melting snow in front of the hardware store...

... Past the bakery where the sugar cookies were still cooling in the window.

Today she did not seem to see the mounds of ginger cakes and cream puffs...Mimi only looked down at her baby.

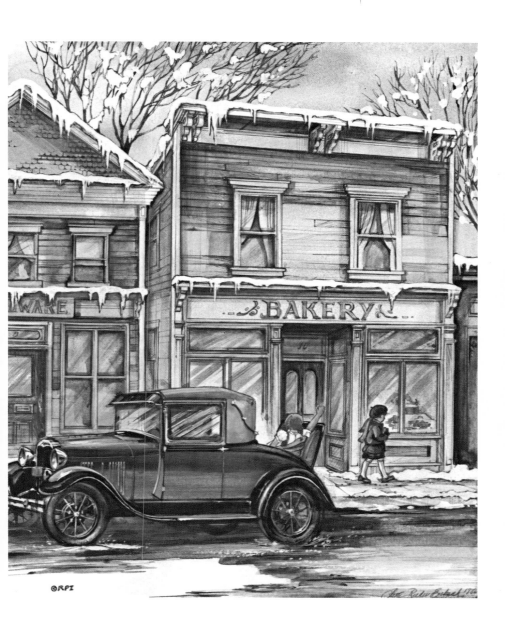

Mimi's friend Suzy was sitting in the rumble seat of her dad's car but Mimi did not notice her.

Barely stopping at the corner she continued to make her way through the slush. Without looking in either direction she crossed the street.

Mimi walked directly to Doctor Chrisfield's office. She knocked impatiently with her mittened hand on the stout oak door.

The door did not open.
She knocked again and again.

Mr. Rockwell knew she had something on her mind.

He was concerned because he sensed his little friend was troubled.

It was now Mr. Rockwell's turn to be anxious. He chewed on the stem of his pipe.

"Why doesn't the doctor open the door?" he wondered.

At that moment the door opened and the
portly, silver-haired doctor stepped
back at the sight of the little girl on
his doorstep.

"Why Mimi!" he boomed.

"Come in! Come on in out of the cold," he urged.

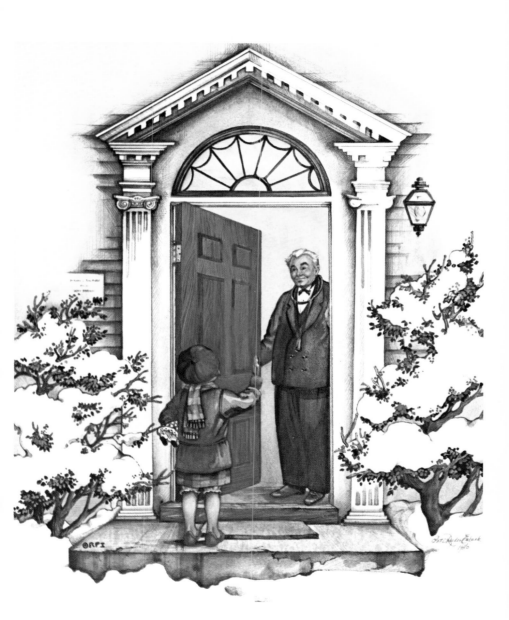

Mr. Rockwell no longer worried about Mimi. He relaxed and puffed on his pipe. He knew his big friend, Doctor Chrisfield, would help his little friend.

Mimi stood on the steps gazing up at the surprised doctor. Her eyes were filled with tears and her face glowed from the winter wind. She did not speak. She only sobbed and clutched her doll.

The doctor knew Mimi very well.
He knew her as a happy little girl.
She puzzled him too.

"Well, Well, what do we have here?"
he asked.
"Oh Doctor Chrisfield," Mimi cried,
"it is my best doll but he
can't say 'Ma-ma' anymore."

"Did you drop him, perhaps you
hugged him too hard?" The
doctor teased.

"Oh no, I didn't hurt him," she sobbed. The tears streamed down her rosy cheeks spilling onto her green leather jacket.

The troubled doctor did not know what to do. He was disturbed by Mimi's problem because it made him realize that many years had passed since he had been confronted with such a dilemma.

"Does your mother know where you are?"
he asked, looking at his watch.

No longer smiling, Doctor Chrisfield
appeared to be tired and distracted.

"No sir," murmured Mimi, "nobody
looked at my baby at home. They were
all too busy so I came to see you.
You always make me better when I'm sick."

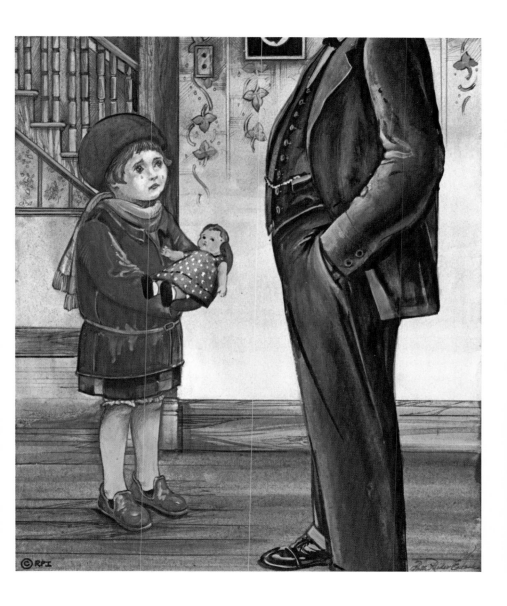

"Dear child," said the doctor, "it has been a long time since I have repaired a doll. I was about to close my office because I have many house calls to make. Now you come to me with this problem."

He lifted the doll from Mimi's grasp and placed it on his desk.

"Come back tomorrow. Perhaps I will find time in the morning to fix your baby."

He turned away from Mimi and walked into the hallway toward his heavy black coat.

Mimi lifted the doll from the doctor's desk and bit her lower lip to hold back the tears.

As Doctor Chrisfield removed his coat from the rack, he turned to see Mimi struggling to open the door. She was very unhappy.

"Just a minute, young lady, where do you think you're going?"

Mimi did not look at the doctor. She dropped her head and sobbed, "I can't leave my baby here, I'm going to take him home with me!"

"You'll do no such thing!" the doctor
scolded. The room became very quiet.
The only sounds to be heard were Mimi's
jerking sobs.

The doctor stood still and thoughtful
for a long moment, then he hung his coat
back on the rack.

He smiled at his two little patients
as he murmured to himself...

"What an old fool I am. How could I have forgotten that it is not always necessary to feel pain when the heart is aching...?"

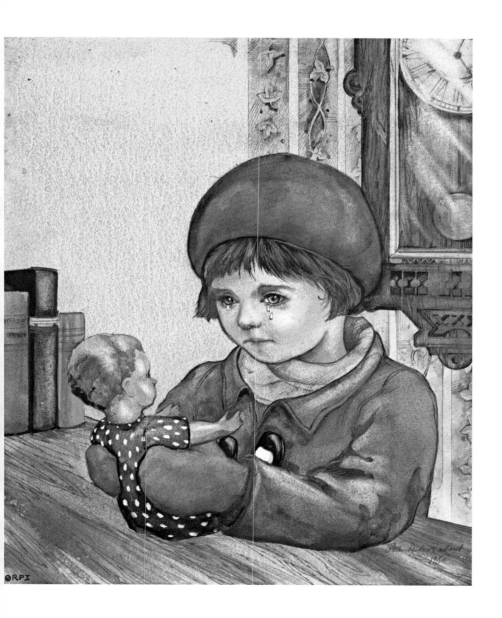

With a slow deliberate movement he grasped a big gold watch from his vest pocket.

Mimi gazed up into his smiling eyes.

Doctor Chrisfield sat down at the large oak desk. He bent low, reaching into the black leather bag at his feet to pull a stethoscope from it.

"Please remove the baby's clothing," he said to the startled little girl.

Doctor Chrisfield's spirit was renewed. His face glowed with the joy of the moment.

Mimi was hesitant but she did what the doctor ordered. Tucking the baby's clothing under her arm, she walked toward the doctor.

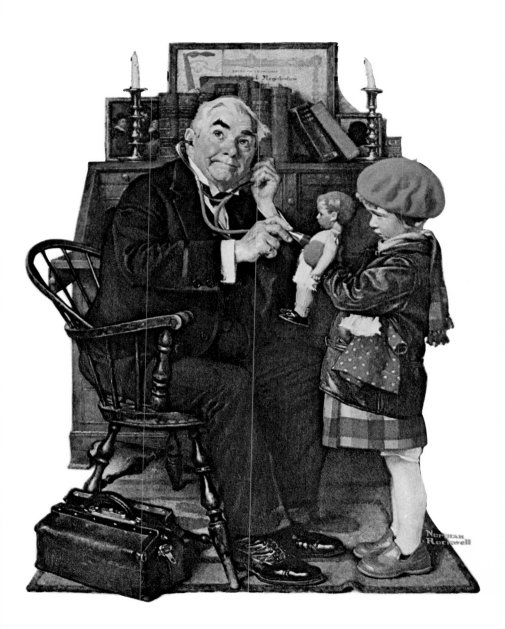

He placed the stethoscope on the baby in the outstretched arms of the anxious little mother.

Doctor Chrisfield's assuring manner was in harmony with the look of confidence on his gentle face.

"My goodness," he whispered, "I do believe we have a problem here...but give me a moment to see what I can do."

He took the baby from Mimi. He placed it face down on his lap, then smacked the baby several times with the palm of
his hand.

Mimi stared at him...shocked.

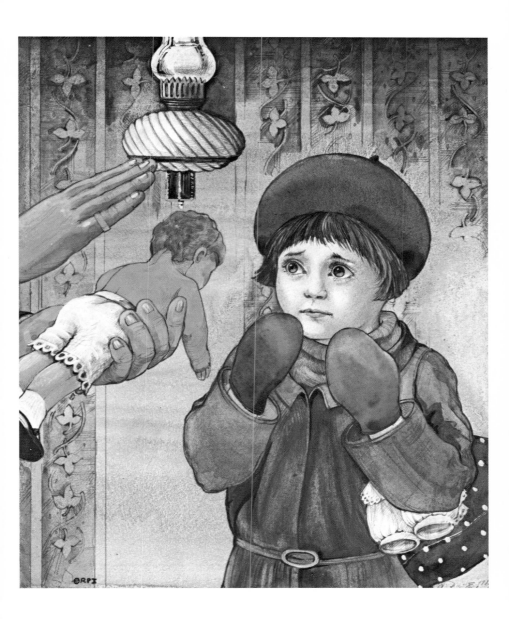

The smiling doctor lifted the baby up toward the surprised girl. As he did so the baby began to cry. It sounded like "Me-Me" instead of "Ma-Ma".

Mimi's eyes opened almost as wide as her mouth. She was amazed. The doctor's grin was joyous.

Mr. Rockwell was again curious about Mimi. He paced the floor and chewed on the stem of his pipe as he watched for her to come out of the doctor's office.

When the big oak door opened and he saw the happy face of his little friend, Mr. Rockwell knew he must get busy. Now, he had a story to paint. He would call his picture, "Doctor and Doll."

THE END

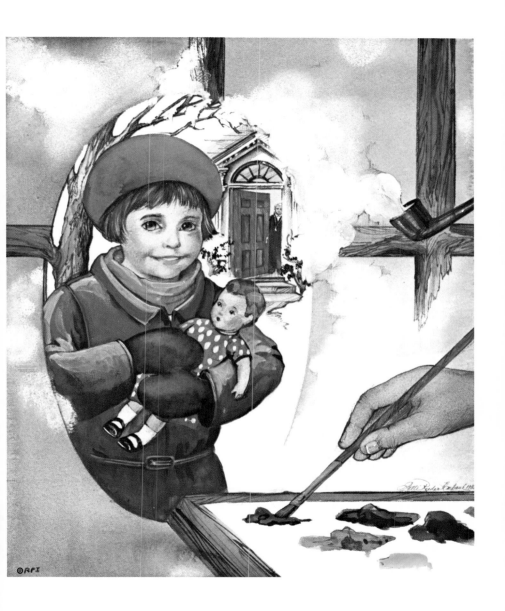